FUN FUN FUN – ANIMAL COLORING BOOK 1

Vedha. B
Sruthi. B
Pranav. B

Fun Fun Fun – Animal coloring book 1 Copyright © 2019 by Vedha. B, Sruthi. B, Pranav. B All Rights Reserved.

All rights reserved. No part of this book may be reproduced in any form or by any electronic or mechanical means including information storage and retrieval systems, without permission in writing from the author. The only exception is by a reviewer, who may quote short excerpts in a review.

First Printing: April 2019
Samvatsara Publications

www.ingramcontent.com/pod-product-compliance
Lightning Source LLC
Chambersburg PA
CBHW081023170526
45158CB00010B/3142